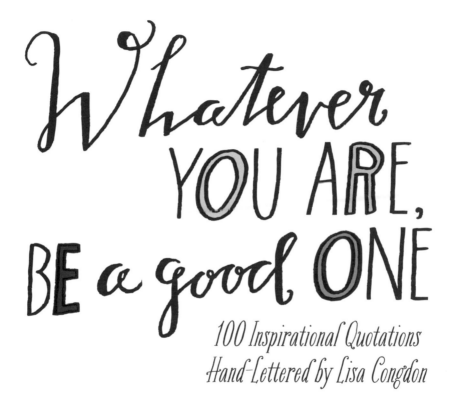

Whatever YOU ARE, BE *a good* ONE

100 Inspirational Quotations
Hand-Lettered by Lisa Congdon

CHRONICLE BOOKS
SAN FRANCISCO

For Clay Walsh.
You are my sun, my moon, and my stars.

Page 107 constitutes a continuation of the copyright page.

Library of Congress Cataloging-in-Publication Data available.

ISBN:978-1-4521-2483-4

Manufactured in China.

Design by Kristen Hewitt

20 19 18 17 16 15 14 13 12 11

Chronicle Books LLC
680 Second Street
San Francisco, CA 94107

www.chroniclebooks.com

"You can't wait for inspiration.
You have to go after it with a club."
—Jack London

I remember it happened on a cold and rainy Sunday afternoon. I tend to lose myself in big, thick, hardbound art books when the weather is dreary, and I was looking through a copy of the *American Illustration Annual* as I curled up on the sofa. I was marking pages I found pretty or interesting and making notes of illustrators whose work I admired. I noticed that on many of the pages I marked, the artists thoughtfully integrated hand lettering into their illustrations. I realized I was clearly drawn to lettering as an art form (and had been for years), and yet I used it minimally in my own work.

So I came up with an idea. To practice, I'd hand-letter *something*—a letter of the alphabet, a word, a poem, a song lyric, a quote—every day for a year. I find enormous inspiration in challenging myself to try new things, and this seemed the perfect project to launch a new year. The project would push me to become a more proficient letterer and to develop my own style. I'd publish the results daily on my blog. The project would be called *365 Days of Hand Lettering*.

And so it began on January 1. I started with letters of the alphabet, alternating between awkwardly attempting traditional calligraphy with a nib and ink and developing my own styles of lettering with a Micron pen (in the end, the Micron pen won out). In February, I moved from letters of the alphabet to whole words and then phrases. A couple of months into the project, I expanded my repertoire and began lettering quotes by famous people and occasionally poems by some of my favorite poets.

The truth was, I'd been collecting quotes and short poems from some of my favorite writers and thinkers in my handwritten journals for years, but hadn't until then found a way to bring them to life. I went back and searched for many of the favorite quotes I'd previously collected and then started collecting new ones. I began to keep a running list on the desktop of my computer.

I found that I loved lettering quotes. That may have been because searching for beautiful or inspiring quotes from my artistic and literary heroes broke the monotony of the daily lettering process. It may also have been because my blog readers responded so positively to the quotes—far more so than to anything else I lettered previously in the project. Clearly the quotes that I found inspiring or funny were resonating with other people. I got e-mail after e-mail from blog readers about how different quotes and poems comforted them in times of darkness or reminded them to approach a challenge in a new way. Suddenly *365 Days of Hand Lettering* became about more than *just* my hand lettering. It was also about celebrating the words of writers, thinkers, and artists, and about inspiring others with those words.

The combination proved to be magical for me: Just when I was tiring of the daily lettering practice, I gained renewed motivation to get up every morning and grab my pen. The quotes I selected began to reflect whatever was on my mind on a particular day. When I traveled through Scandinavia in September, the quotes were about adventure. When I felt sad, the quotes I lettered were about mourning or darkness. When I felt inspired, the quotes were about joy and hope. I am a person who wakes up every morning and thinks about the differences I can make each day in the world—through my relationships, my encounters with people, and through my work. So many of the quotes were based on a call to action: how to be a better person. The daily practice of hand lettering became a way for me to express my innermost feelings and aspirations.

This book is a collection of one hundred of my favorite quotes (and a few poems). Most are from my *365 Days of Hand Lettering* project, along with several additions. It has been a joy for me to put them together into a book for others to ponder. I hope very much that you find something in this book that inspires you to do something new yourself, introduces you to a new artist or writer, or creates in you a new sense of wonder.

Enjoy!

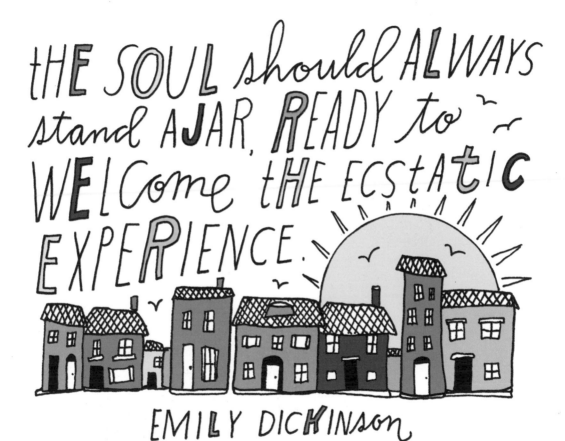

THE SOUL should ALWAYS stand AJAR, READY to WELcome THE ECStATiC EXPERiENCE.

EMILY DICKINSON

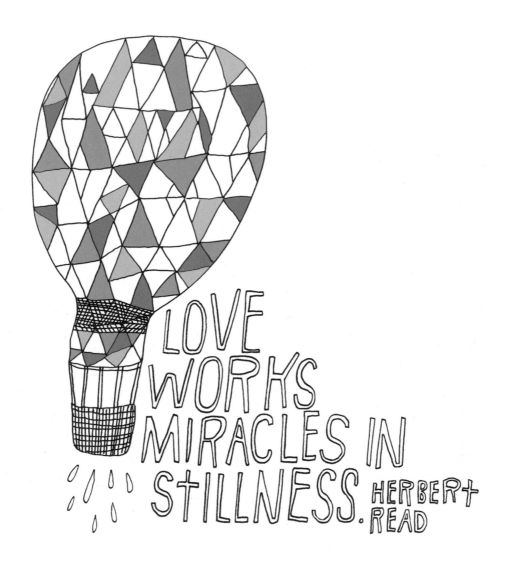

LOVE
WORKS
MIRACLES IN
STILLNESS. HERBER+
READ

It is not the light that we need, but fire; it is not the gentle shower, but thunder. We need the storm, the WHIRLWIND, and the earthquake.

FREDERICK DOUGLASS

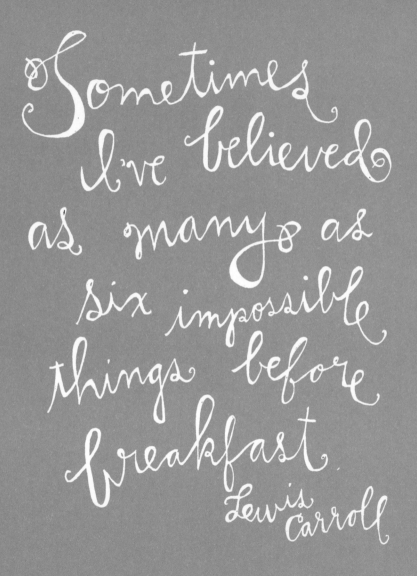

Sometimes I've believed as many as six impossible things before breakfast.

Lewis Carroll

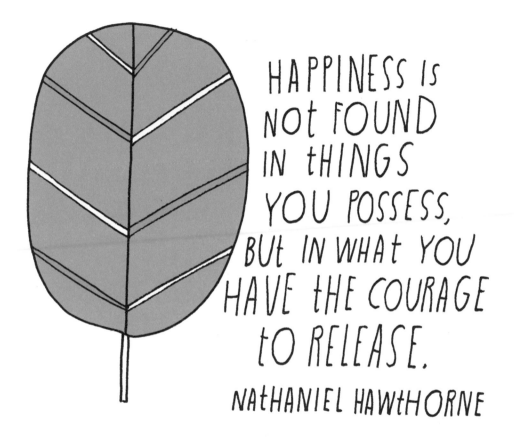

HAPPINESS is
NOT FOUND
IN tHINGS
YOU POSSESS,
BUT IN WHAT YOU
HAVE tHE COURAGE
tO RELEASE.
NAtHANIEL HAWtHORNE

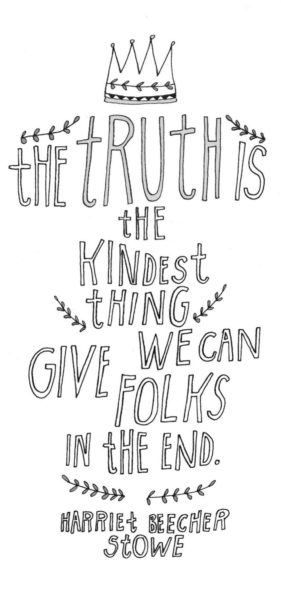

the truth is the kindest thing we can give folks in the end.

HARRIET BEECHER STOWE

WISDOM
BEGINS
IN WONDER
-SOCRATES-

I BELIEVE tHAt
IF ONE ALWAYS LOOKED
At tHE SKIES,
ONE WOULD END UP
WITH WINGS.

GUStAVE FLAUBERt

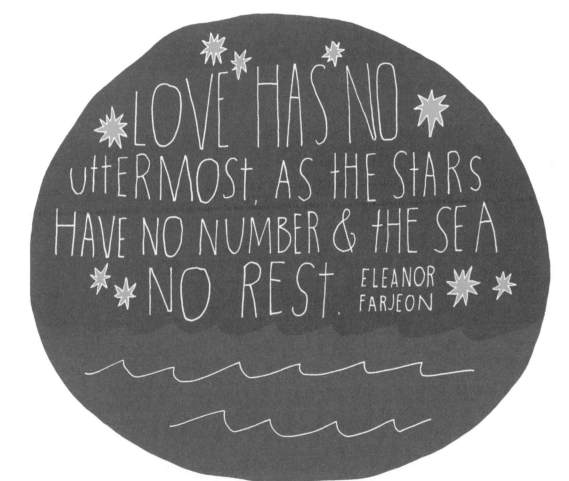

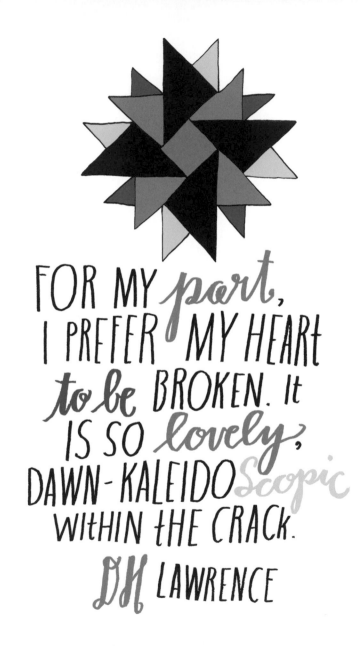

FOR MY *part,*
I PREFER MY HEART
to be BROKEN. It
IS SO *lovely,*
DAWN-KALEIDO*scopic*
WITHIN THE CRACK.
DH LAWRENCE

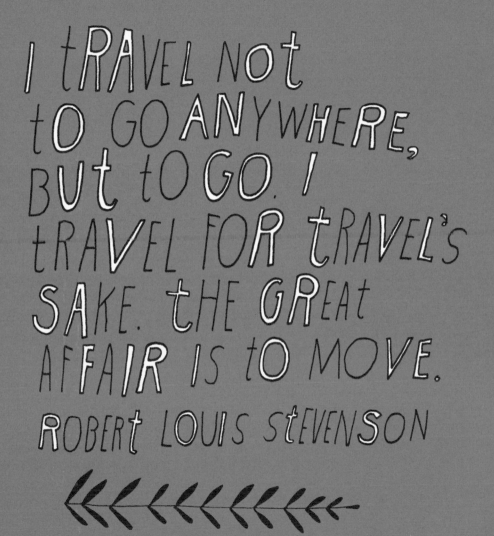

I TRAVEL NOT
TO GO ANYWHERE,
BUT TO GO. I
TRAVEL FOR TRAVEL'S
SAKE. THE GREAT
AFFAIR IS TO MOVE.
ROBERT LOUIS STEVENSON

ONLY WHEN HE NO LONGER KNOWS WHAT HE IS DOING DOES the PAINtER DO GOOD things. "EDGAR DEGAS"

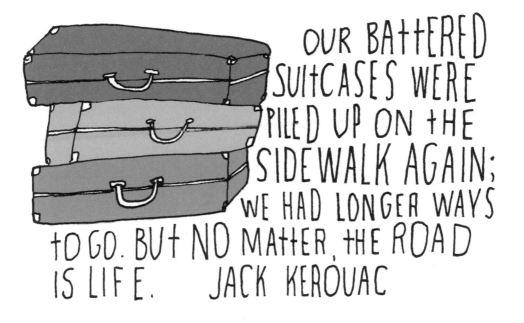

OUR BATTERED
SUITCASES WERE
PILED UP ON THE
SIDEWALK AGAIN;
WE HAD LONGER WAYS
TO GO. BUT NO MATTER, THE ROAD
IS LIFE. JACK KEROUAC

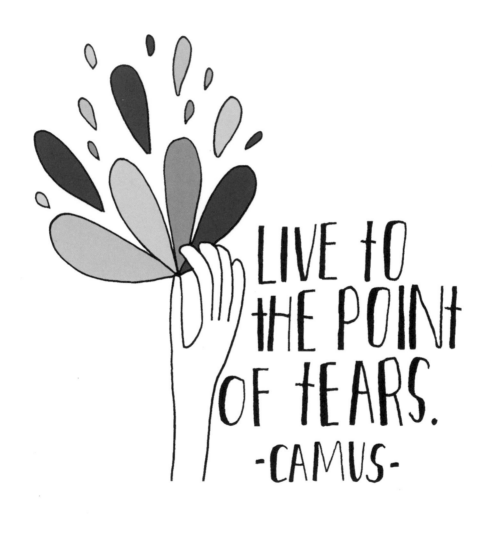

LIVE tO
THE POINt
OF tEARS.
-CAMUS-

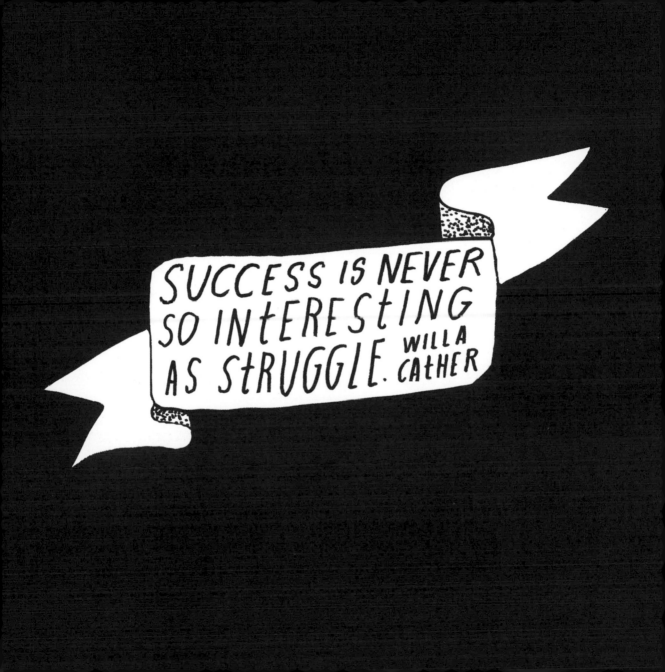

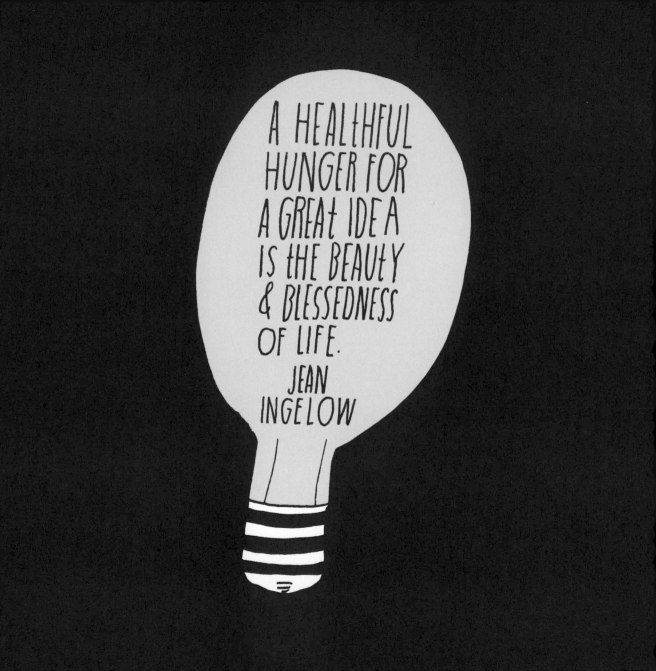

NO insect HANGS
its NESt ON threads
AS FRAIL as tHOSE
WHICH will SUStAIN

the WEIGHt of
HUMAN VANItY.

EDItH Wharton

Consistency is the last Refuge of the Unimaginative.

Oscar Wilde

You cant wait for inspiration. You have to go after it with a club.

Jack London

SELF-KNOWLEDGE is no guarantee OF HAPPINESS, BUT IT IS ON the side of HAPPINESS AND CAN supply the courage TO FIGHT for it.

SIMONE DE BEAUVOIR

WE SHALL FIND PEACE.
WE SHALL HEAR ANGELS,
WE SHALL SEE THE SKY
SPARKLING WITH DIAMONDS.

ANTON
CHEKHOV

LET US READ, and LET US DANCE; THESE two AMUSEMENts WILL NEVER DO ANY harm to THE WORLD. VOLTAIRE

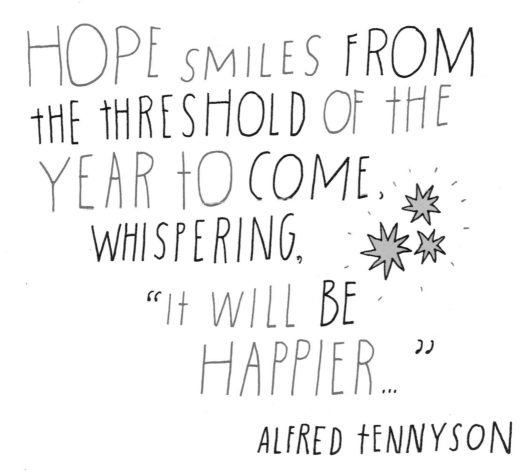

HOPE SMILES FROM THE THRESHOLD OF THE YEAR TO COME, WHISPERING, "IT WILL BE HAPPIER..."

ALFRED TENNYSON

IMAGINATION IS THE EYE OF THE SOUL.

JOSEPH JOUBERT

HAVE NOTHING

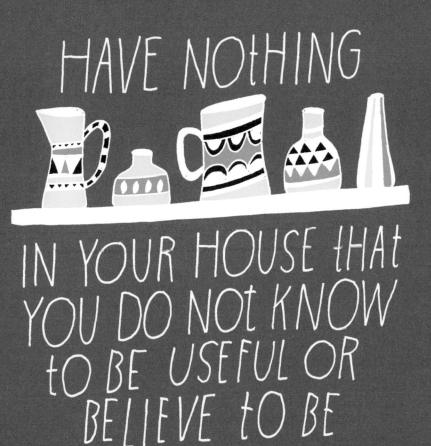

IN YOUR HOUSE tHAt
YOU DO NOt KNOW
tO BE USEFUL OR
BELIEVE tO BE
BEAUtIFUL.

WILLIAM MORRIS

I AM NOt
AFRAID...

I WAS BORN
tO DO tHIS.
— ˅˅˅ —

JOAN of ARc

IF YOU HEAR THE DOGS,
KEEP GOING.
IF YOU SEE THE TORCHES
IN THE WOODS,
KEEP GOING.
IF THERE'S SHOUTING AFTER YOU,
KEEP GOING.

DON'T EVER STOP.
KEEP GOING.
IF YOU WANT THE TASTE
OF FREEDOM,
KEEP GOING.

HARRIET TUBMAN

It is good to love many things, for therein lies the true strength, and whosoever loves much performs much, and can accomplish much and what is done in love is well done.
Vincent Van Gogh

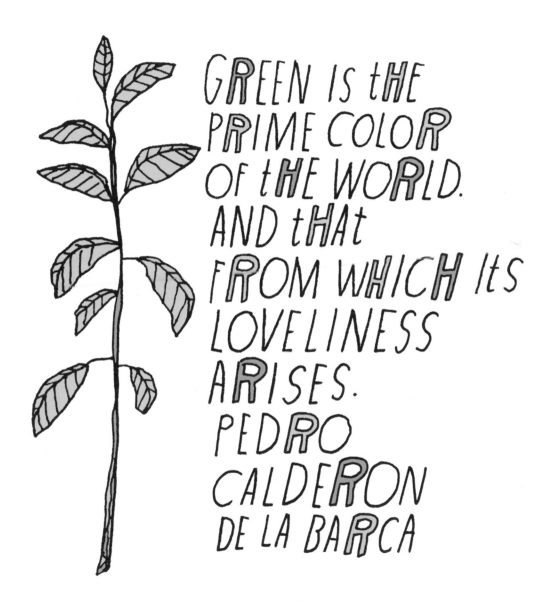

GREEN IS THE PRIME COLOR OF THE WORLD. AND THAT FROM WHICH ITS LOVELINESS ARISES.

PEDRO CALDERON DE LA BARCA

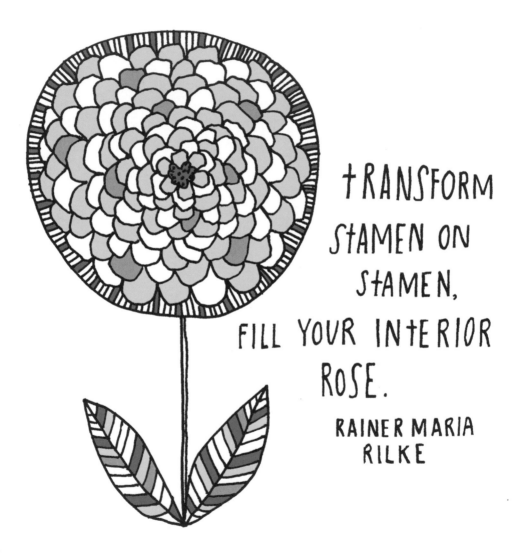

tRANSFORM STAMEN ON STAMEN,
FILL YOUR INTERIOR ROSE.

RAINER MARIA RILKE

THAT EVERYONE
is identical
IN THEIR SECRET
unspoken
BELIEF THAT WAY
deep down they
ARE DIFFERENT
from everyone
ELSE.

david foster wallace

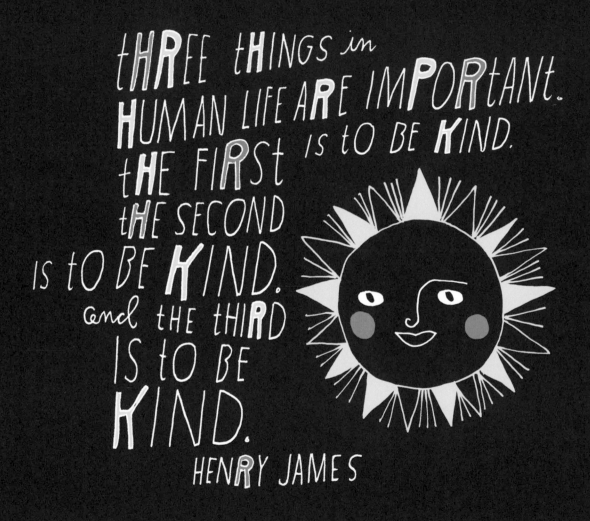

three things in human life are important. the first is to be kind. the second is to be KIND. and the third is to be KIND.

HENRY JAMES

GRATITUDE IS THE MEMORY OF THE HEART. ♥

JEAN MASSIEU

tHE *thankful* RECEIVER
BEARS A PLENtiFUL *harvest.*

William Blake

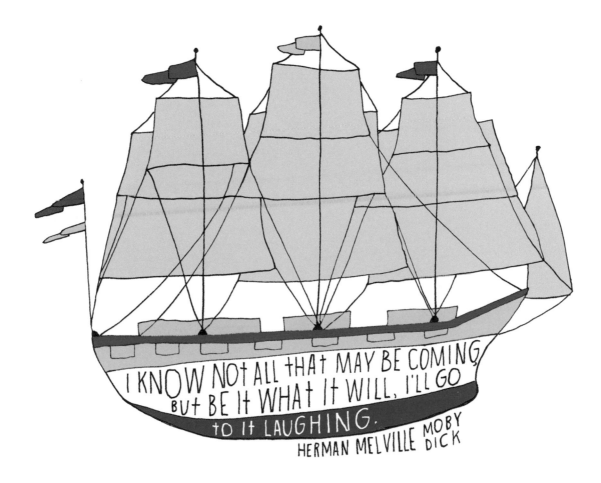

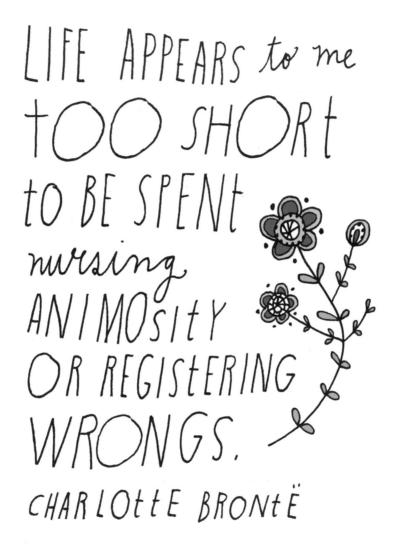

LIFE APPEARS to me TOO SHORT to BE SPENT nursing ANIMOSITY OR REGISTERING WRONGS.

CHARLOTTE BRONTË

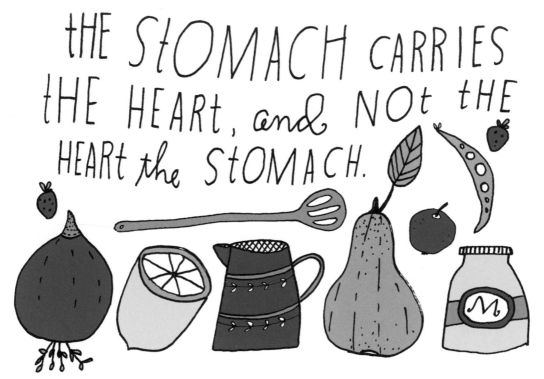

THE STOMACH CARRIES THE HEART, and NOT THE HEART the STOMACH.

MIGUEL DE CERVANTES

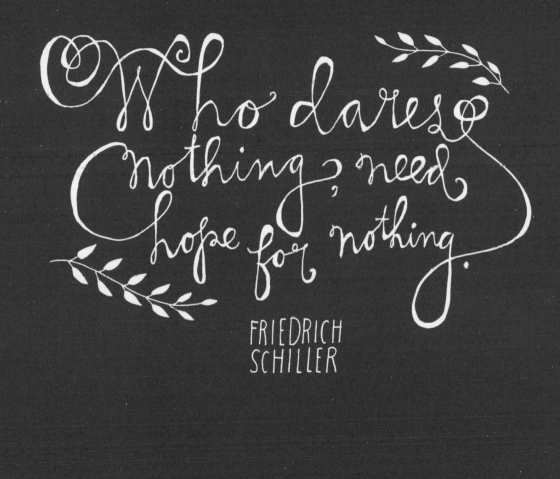

Who dares nothing, need hope for nothing.

FRIEDRICH SCHILLER

IF I WERE to wish for anything, I should not wish for wealth & power, but for the passionate sense of the potential for the eye which, ever young & ardent, sees the possible. Pleasure disappoints, possibility never. And what wine is so sparkling, what so fragrant, what so intoxicating, as possibility!

SØREN KIERKEGAARD

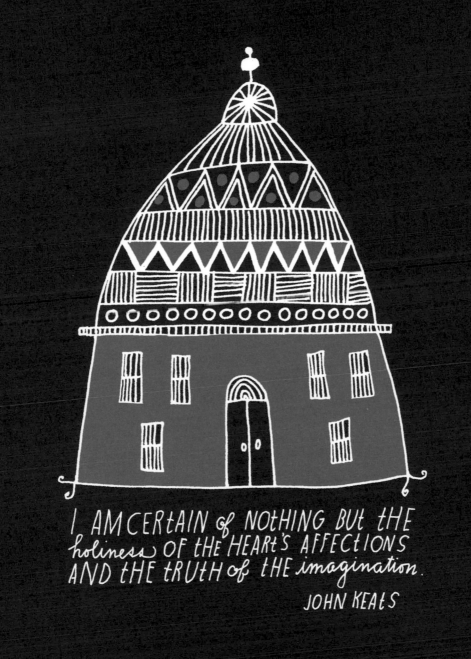

I AM CERTAIN of NOTHING BUT tHE holiness OF THE HEARt's AFFECtIONS AND THE tRUtH of THE imagination.

JOHN KEAtS

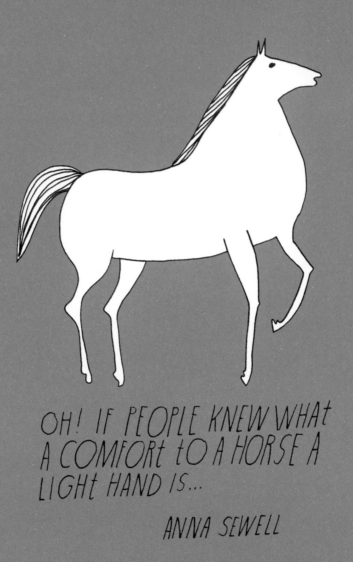

OH! IF PEOPLE KNEW WHAT
A COMFORT TO A HORSE A
LIGHT HAND IS...

ANNA SEWELL

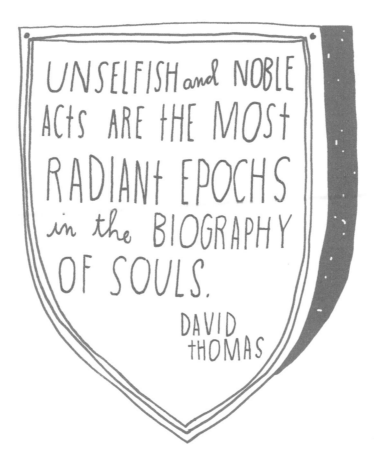

UNSELFISH and NOBLE Acts ARE THE MOST RADIANT EPOCHS in the BIOGRAPHY OF SOULS.

DAVID THOMAS

GOOD PEOPLE ARE
GOOD BECAUSE
THEY'VE COME
to WISDOM
tHROUGH
FAILURE.

WILLIAM SAROYAN

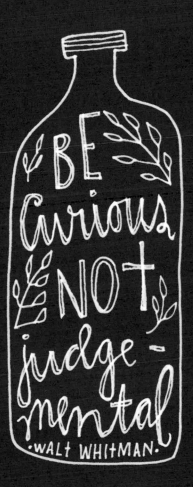

BE Curious NOT judge-mental

·WALT WHITMAN·

LOOK PAST YOUR thoughts
SO YOU MAY DRINK THE
PURE NECtAR OF THIS
MOMENt.
RUMI

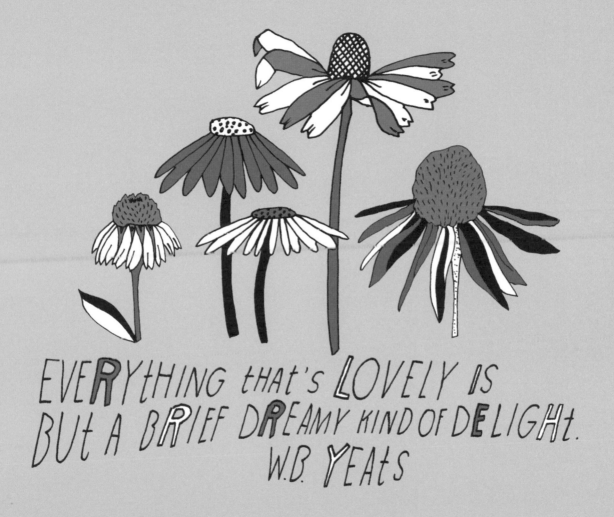

EVERYthing that's LOVELY is
BUt A BRIef DREamY KIND OF DELIGHt.
W.B. YEAts

"you have some queer friends, Dorothy,"
SHE SAID.

"The queerness doesn't matter, so long as they're friends."
WAS THE ANSWER.

L. FRANK BAUM

EVERY TIME
I SEE AN
ADULT ON
A BICYCLE,
I NO LONGER
DESPAIR FOR
THE FUTURE OF
THE HUMAN RACE.
H.G. WELLS

WE can KNOW
ONLY that WE know
nothing. AND that
is the Highest degree
of human wisdom.
LEO tolstOY

The STILL small voice OF Gratitude.

Thomas Gray

tALENt IS A LONG PATIENCE, AND ORIGINALITY AN EFFORt OF WILL AND INtENSE OBSERVATION.

GUStAVE FLAUBERt

tHERE is NO SINCERER LOVE than the LOVE of LOVE FOOD.

GEORGE BERNARD SHAW

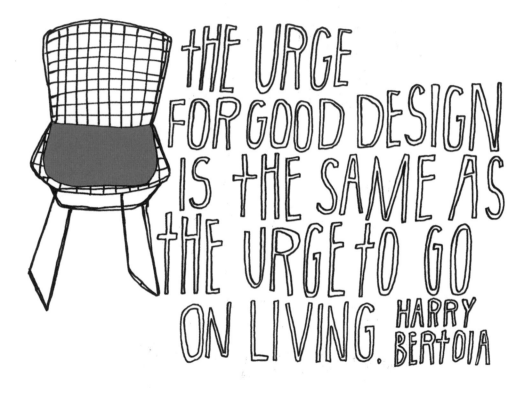

THE URGE FOR GOOD DESIGN IS THE SAME AS THE URGE TO GO ON LIVING. HARRY BERTOIA

THIS IS WHAT SEPARATES
ARTISTS FROM ORDINARY PEOPLE:
THE BELIEF, DEEP IN OUR HEARTS, THAT
IF WE BUILD OUR CASTLES WELL
ENOUGH, SOMEHOW THE OCEAN WON'T
WASH 'THEM AWAY.
ANNE LAMOTT

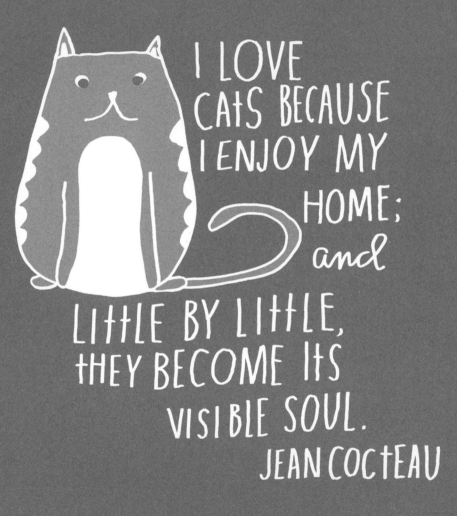

I LOVE CATS BECAUSE I ENJOY MY HOME; and LITTLE BY LITTLE, THEY BECOME ITS VISIBLE SOUL.

JEAN COCTEAU

May you live
every day
of your
life.

Jonathan Swift

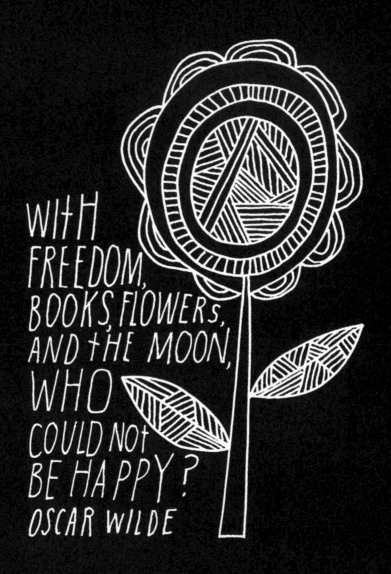

WITH
FREEDOM,
BOOKS, FLOWERS,
AND THE MOON,
WHO
COULD NOT
BE HAPPY?
OSCAR WILDE

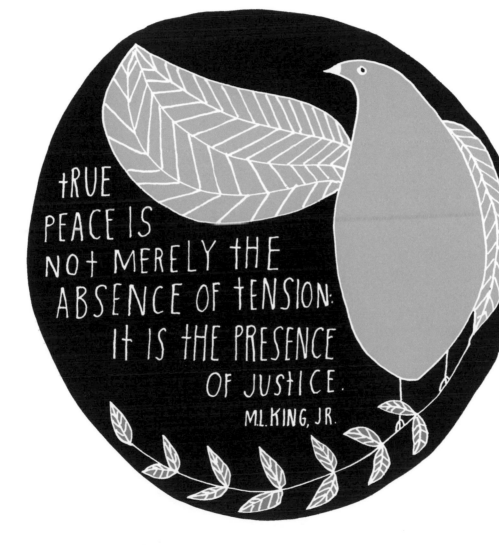

There is a sacredness in tears. They are not a mark of weakness, but of power. They speak more eloquently than ten thousand tongues. They are the messengers of overwhelming grief, of deep contrition and of unspeakable love.

WASHINGTON IRVING

tHERE ARE NO IMPOSSIBLE
OBStACLES; tHERE
ARE JUSt StRONGER and
WEAKER WILLS...

JULES VERNE

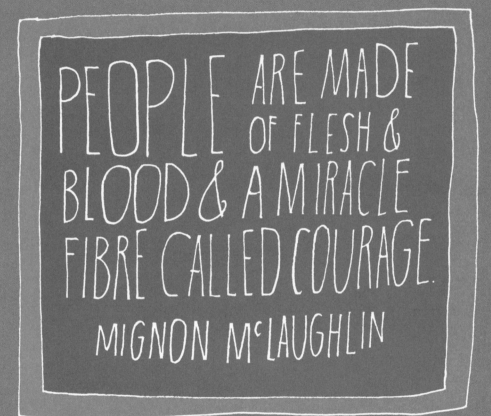

PEOPLE ARE MADE OF FLESH & BLOOD & A MIRACLE FIBRE CALLED COURAGE.

MIGNON McLAUGHLIN

PRAISE THE BRIDGE THAT CARRIED YOU OVER. GEORGE COLMAN - THE YOUNGER

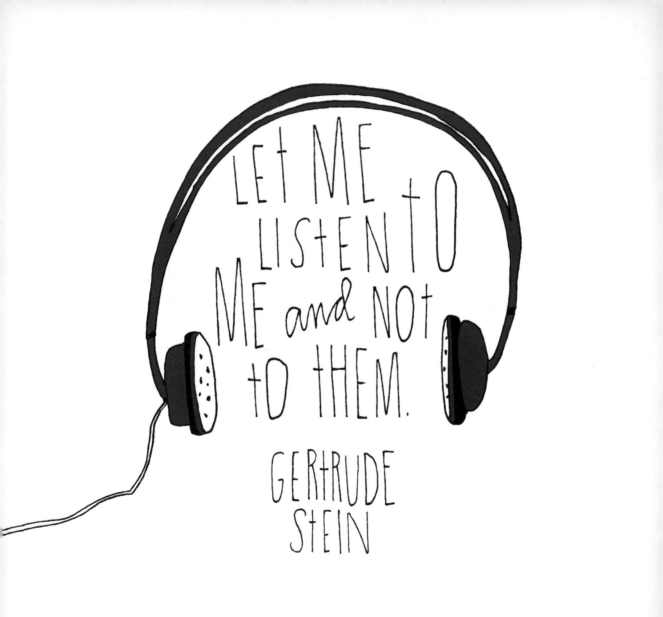

I MYSELF AM MADE ENTIRELY OF FLAWS, STITCHED TOGETHER WITH GOOD INTENTIONS.

AUGUSTEN BURROUGHS

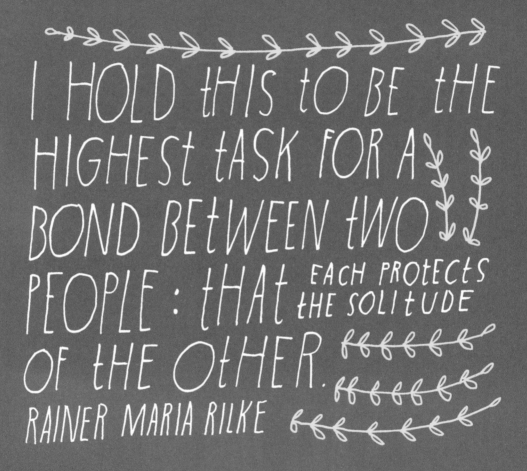

I HOLD tHiS tO BE tHE HIGHEST tASK FOR A BOND BEtWEEN tWO PEOPLE : tHAt EACH PROtECtS tHE SOLItUDE OF tHE OtHER.

RAINER MARIA RILKE

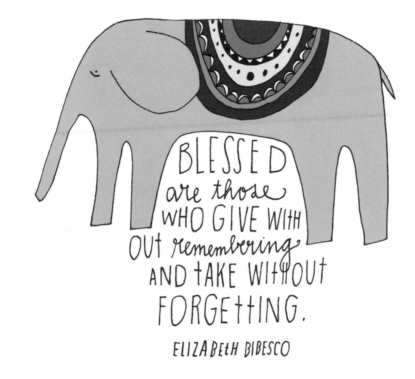

BLESSED are those WHO GIVE WITHOUT remembering AND TAKE WITHOUT FORGETTING.

ELIZABETH BIBESCO

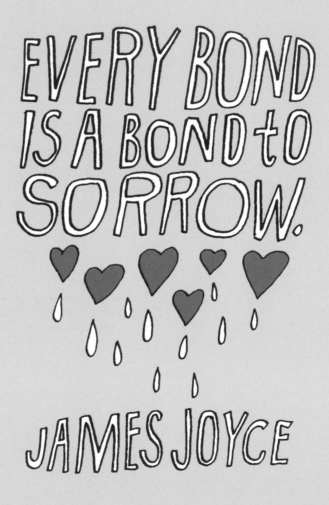

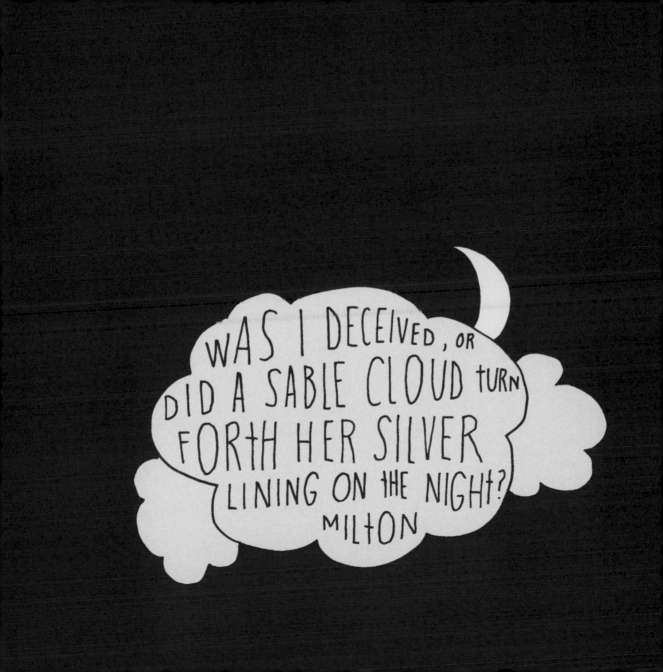

TALENT IS CHEAPER
THAN TABLE SALT.
WHAT SEPARATES THE
TALENTED INDIVIDUAL
FROM THE SUCCESSFUL
ONE IS A LOT OF
HARD WORK.
STEPHEN KING

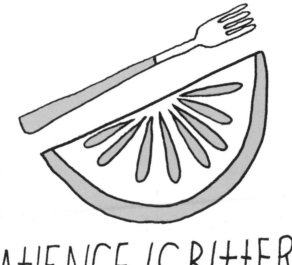

PATIENCE IS BITTER
BUT ITS FRUIT IS SWEET.
JEAN-JACQUES ROUSSEAU

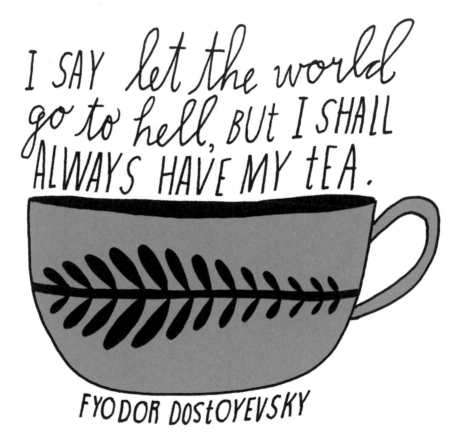

I SAY *let the world* *go to hell,* BUT I SHALL ALWAYS HAVE MY TEA.

FYODOR DOSTOYEVSKY

NOTHING IN LIFE
IS TO BE FEARED, IT
IS ONLY TO BE
UNDERSTOOD.
— MARIE CURIE

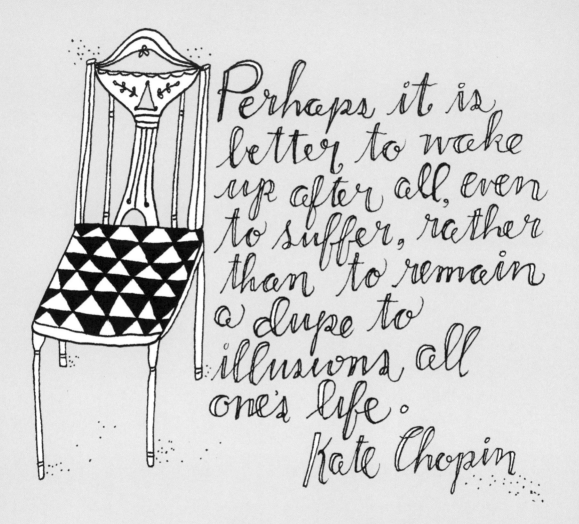

Perhaps it is better to wake up after all, even to suffer, rather than to remain a dupe to illusions all one's life.

Kate Chopin

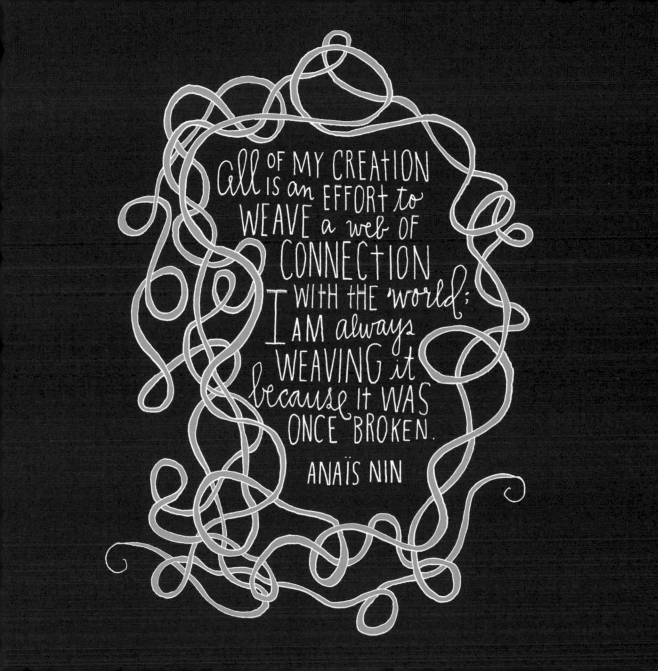

all OF MY CREATION IS an EFFORT to WEAVE a web OF CONNECTION I WITH THE 'world; I AM always WEAVING it because IT WAS ONCE 'BROKEN.

ANAÏS NIN

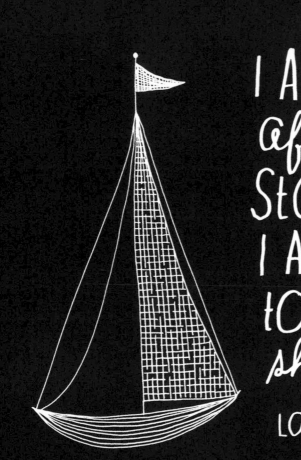

I AM NOT *afraid* OF STORMS, FOR I AM *learning* to SAIL MY *ship*.

LOUISA MAY ALCOTT

... NOTHING CONTRIBUTES SO MUCH TO TRANQUILIZE THE MIND AS A STEADY PURPOSE.

MARY SHELLEY

ARTISTIC DISCIPLINE and
ATHLETIC DISCIPLINE ARE
kissing Cousins, THEY REQUIRE
THE same THING, AN UNSPECIAL
PRACTICE : tedious and
PITCH-BLACK INVISIBLE,
private AS GUTS, BUT ALWAYS
SACRED.

LEANNE SHAPTON

I learned to make my mind large, as the universe is large, so that there is room for paradoxes.
Maxine Hong Kingston

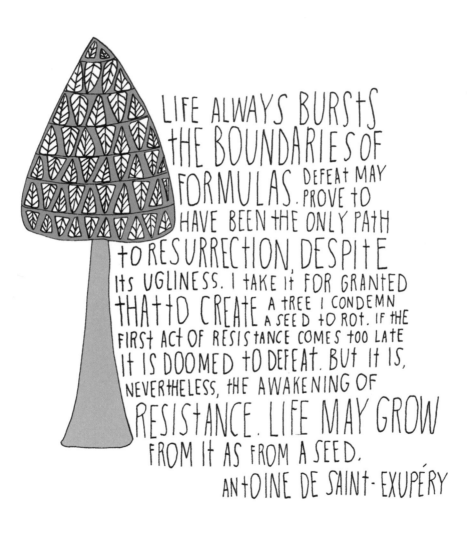

LIFE ALWAYS BURSTS THE BOUNDARIES OF FORMULAS. DEFEAT MAY PROVE TO HAVE BEEN THE ONLY PATH TO RESURRECTION, DESPITE its UGLINESS. I TAKE it FOR GRANTED THAT TO CREATE A TREE I CONDEMN A SEED TO ROT. IF THE FIRST ACT OF RESISTANCE COMES TOO LATE IT IS DOOMED TO DEFEAT. BUT it IS, NEVERTHELESS, THE AWAKENING OF RESISTANCE. LIFE MAY GROW FROM it AS FROM A SEED.

ANTOINE DE SAINT-EXUPÉRY

WISHING to BE FRIENDS
IS QUICK WORK, BUt FRIENDSHIP
IS A SLOW RIPENING FRUIt.

ARIStOtLE

EITHER LIFE ENTAILS COURAGE

OR IT CEASES TO BE LIFE.

E.M. FORSTER

TRUE HAPPINESS IS TO ENJOY THE PRESENT, WITHOUT ANXIOUS DEPENDENCE ON THE FUTURE, NOT TO AMUSE OURSELVES WITH EITHER HOPES OR FEARS BUT TO REST SATISFIED WITH WHAT WE HAVE, WHICH IS SUFFICIENT, FOR HE THAT IS SO WANTS NOTHING. THE GREATEST BLESSINGS OF MANKIND ARE WITHIN US AND WITHIN OUR REACH. A WISE MAN IS CONTENT WITH HIS LOT, WHATEVER IT MAY BE, WITHOUT WISHING FOR WHAT HE HAS NOT. ✽ SENECA

AND DID YOU GET WHAT
YOU WANTED FROM THIS LIFE, EVEN SO?
I DID.
AND WHAT DID YOU WANT?
TO CALL MYSELF BELOVED, TO FEEL MYSELF
BELOVED ON THE EARTH.

RAYMOND CARVER
LATE FRAGMENT

let us be
grateful
to PEOPLE
who make US
HAPPY. THEY are the
charming GARDENERS
WHO MAKE our souls
blossom.

MARCEL
PROUST

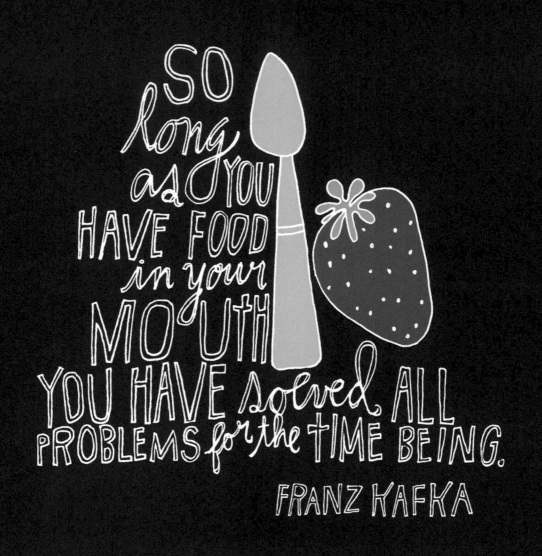

So long as you have food in your mouth you have solved all problems for the time being.

FRANZ KAFKA

Let other pens dwell on guilt and misery.

Jane Austen

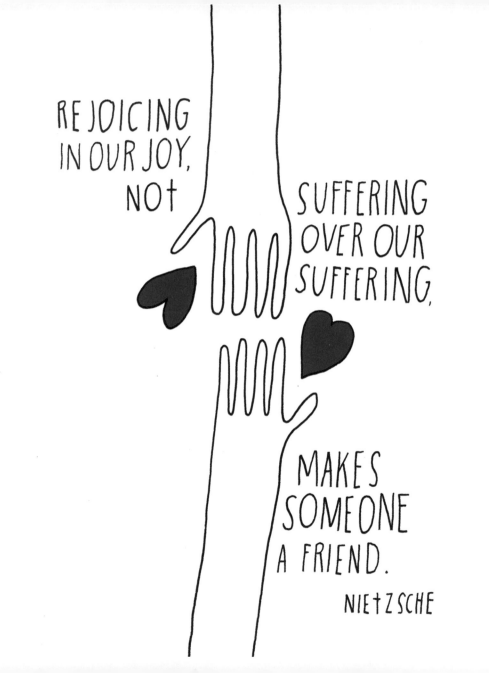

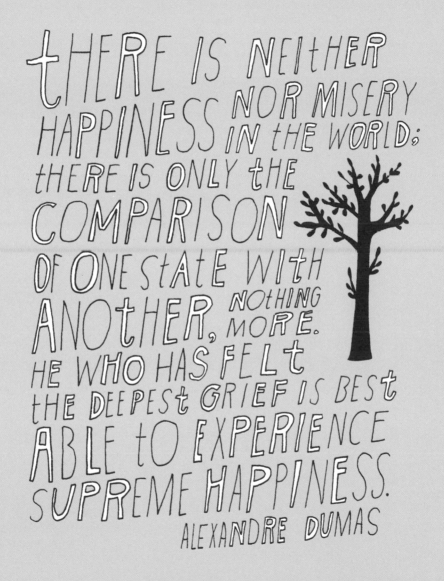

THERE IS NEITHER HAPPINESS NOR MISERY IN THE WORLD; THERE IS ONLY THE COMPARISON OF ONE STATE WITH ANOTHER, NOTHING MORE. HE WHO HAS FELT THE DEEPEST GRIEF IS BEST ABLE TO EXPERIENCE SUPREME HAPPINESS.

ALEXANDRE DUMAS

LIFE IS NOT A SERIES OF GIG LAMPS SYMMETRICALLY ARRANGED; LIFE IS A LUMINOUS HALO, A SEMI-TRANSPARENT ENVELOPE SURROUNDING US FROM THE BEGINNING OF CONSCIOUSNESS TO THE END. -VIRGINIA WOOLF

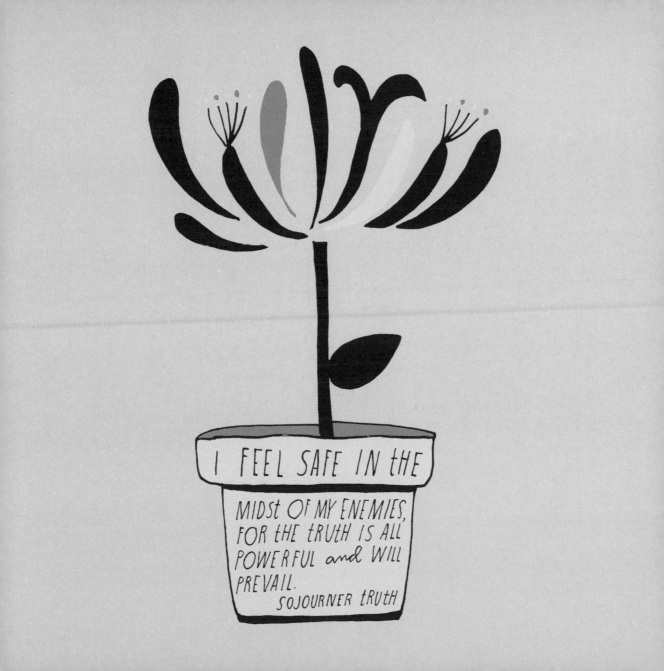

I FEEL SAFE IN THE MIDST OF MY ENEMIES, FOR THE TRUTH IS ALL POWERFUL and WILL PREVAIL.
SOJOURNER TRUTH

BELIEVE **THERE** IS A GREAT POWER SILENTLY WORKING ALL things FOR **GOOD**, BEHAVE YOURSELF AND NEVER MIND the REST.

BEATRIX POTTER

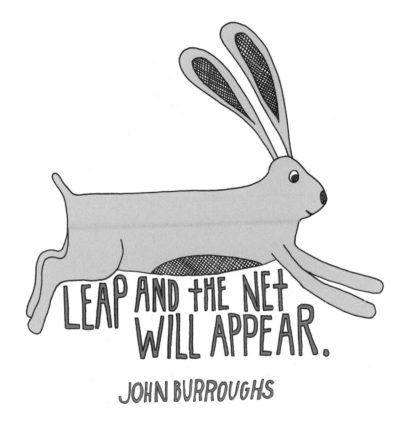

LEAP AND THE NET
WILL APPEAR.

JOHN BURROUGHS

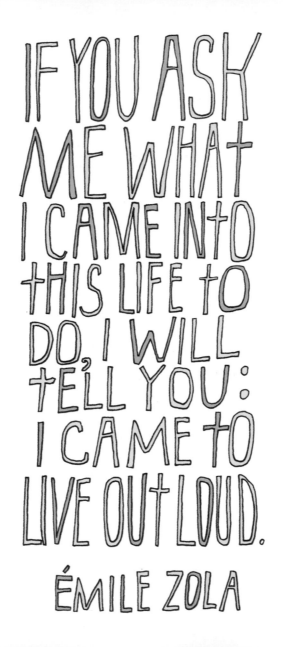

IF YOU ASK ME WHAT I CAME INTO THIS LIFE TO DO, I WILL TELL YOU: I CAME TO LIVE OUT LOUD.

ÉMILE ZOLA

KIND
WORDS
WILL UNLOCK
AN IRON
DOOR.

TURKISH PROVERB

THE AIM
OF LIFE IS
TO LIVE,
AND TO LIVE
MEANS
TO BE AWARE,
JOYOUSLY, DRUNKENLY,
SERENELY, DIVINELY AWARE.
HENRY MILLER

Whatever you are, be a good one.

WILLIAM
MAKEPEACE THACKERAY

Quotation Credits

All quotations not listed are in the public domain.

..

"Love works miracles in stillness."—Herbert Read. From *The Forms of Things Unknown: An Essay on the Impact of the Technological Revolution on the Creative Arts,* 1963, used by permission of David Hingham Agency.

"Our battered suitcases were piled up on the sidewalk again; we had longer ways to go. But no matter, the road is life."—Jack Kerouac. From *On The Road* by Jack Kerouac, copyright © 1955 by Jack Kerouac, renewed © 1983 by Stella Kerouac, renewed © 1985 by Stella Kerouac and Jan Kerouac. Used by permission of Viking Penguin, a division of Penguin Group USA, Inc.

"Live to the point of tears."—Albert Camus. From *Albert Camus, Notebooks,* used by permission of The Rowman & Littlefield Publishing Group.

"Self-knowledge is no guarantee of happiness, but it is on the side of happiness and can supply the courage to fight for it."—Simone de Beauvoir. "Translation", from *Force Of Circumstance* by Simone de Beauvoir, translated by Richard Howard, translation copyright © 1965 by Richard Howard. Used by permission of G.P. Putnam's Sons, a division of Penguin Group (USA) Inc.

"That everyone is identical in their secret unspoken belief that way deep down they are different from everyone else."—David Foster Wallace. From *Infinite Jest.* Used by Permission of the David Foster Wallace Literary Trust.

"The urge for good design is the same as the urge to go on living."—Harry Bertoia. Permission granted by Celia Bertoia for Harry Bertoia.

"This is what separates artists from ordinary people: the belief, deep in our hearts, that if we build our castles well enough, somehow the ocean won't wash them away."—Anne Lamott. From *Bird by Bird: Some Instructions on Writing and Life,* 1995, used by permission of author.

"I love cats because I enjoy my home; and little by little, they become its visible soul."—Jean Cocteau. Permission granted courtesy Comite Jean Cocteau.

COMITÉ
Jean Cocteau

"True peace is not merely the absence of tension: it is the presence of justice."—Martin Luther King, Jr. Reprinted by arrangement with the Heirs to the Estate of Martin Luther King, Jr., c/o Writers House as agent for the proprietor in New York, NY. Copyright © 1958, Dr. Martin Luther King, Jr. © renewed 1986, Coretta Scott King.

"People are made of flesh and blood and a miracle fibre called courage."—Mignon McLaughlin. Courtesy Lilly Library, Indiana University, Bloomington, Indiana.